GREAT
MINDS
DON'T
THINK
ALIKE

An Hachette UK Company
www.hachette.co.uk

First published in the UK in 2018 by ILEX,
a division of Octopus Publishing Group Ltd
Octopus Publishing Group
Carmelite House
50 Victoria Embankment
London EC4Y 0DZ
www.octopusbooks.co.uk
www.octopusbooksusa.com

Distributed in the US by Hachette Book Group
1290 Avenue of the Americas, 4th and 5th Floors,
New York NY 10104

Distributed in Canada by Canadian Manda Group
664 Annette St., Toronto, Ontario, Canada M6S 2C8

Editorial Director: Helen Rochester
Commissioning Editor: Zara Anvari
Managing Editor: Frank Gallaugher
Senior Editor: Rachel Silverlight
Publishing Assistant: Stephanie Hetherington
Art Director: Julie Weir
Design & Illustrations: Modern Activity
Production Manager: Lisa Pinnell

ISBN 978-1-78157-537-6

A CIP catalogue record for this book
is available from the British Library.

Printed and bound in China

10 9 8 7 6 5 4 3 2 1

GREAT MINDS *DON'T* THINK ALIKE

Discover the method & madness of 56 creative geniuses

EMILY GOSLING

ilex

Inspiration exists, but it has to find you working.

— Pablo Picasso

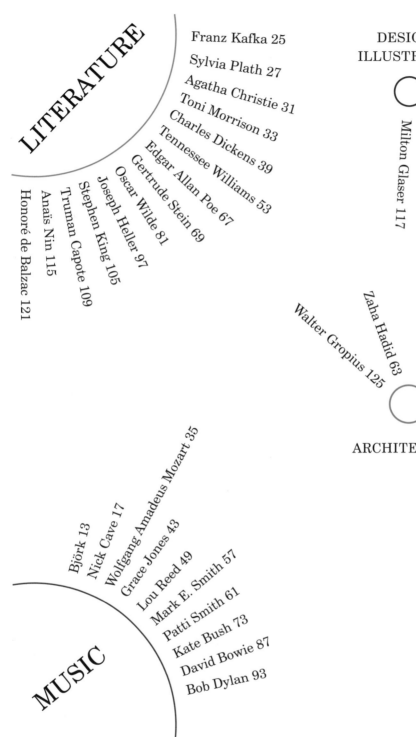

LITERATURE

Franz Kafka 25
Sylvia Plath 27
Agatha Christie 31
Toni Morrison 33
Charles Dickens 39
Tennessee Williams 53
Edgar Allan Poe 67
Gertrude Stein 69
Oscar Wilde 81
Joseph Heller 97
Stephen King 105
Truman Capote 109
Anaïs Nin 115
Honoré de Balzac 121

DESIGN & ILLUSTRATION

Milton Glaser 117
Christoph Niemann 83

ARCHITECTURE

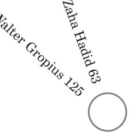

Zaha Hadid 63
Walter Gropius 125

MUSIC

Björk 13
Nick Cave 17
Wolfgang Amadeus Mozart 35
Grace Jones 43
Lou Reed 49
Mark E. Smith 57
Patti Smith 61
Kate Bush 73
David Bowie 87
Bob Dylan 93

Introduction

A 50-cup-a-day coffee habit; obsessive journaling; walking obscene distances; organizing objects pilfered from desert wildernesses; the corporeal as canvas: as the title suggests, this book presents the creative process as being something wildly diverse; methodical yet peppered with glimmers of madness.

It's a strange thing to write about other people's methods as it inherently makes you question your own: You wonder, am I doing this right? Would I work better if I, say, developed a strict exercise regime like Leonardo da Vinci? Would immersing myself in nature like Björk help me to unlock my creativity? Should I just give up now since, unlike David Lynch, I can't meditate properly, let alone Transcendentally?

What made this such a joy to put together, however, was the confirmation that there really is no right or wrong in the creative process. Just as each of these 56 geniuses and their work is utterly individual, so too are the ways in which they go about making it. Hopefully as you read this, as writing it did for me, you'll be encouraged to ponder your own methodical quirks and peccadilloes. That sort of reflection can shed new light on your work and workings, helping you to make the most of the things that work for you. At the same time, the sheer variety of approaches described may inspire you to tackle

creativity in new ways you previously hadn't dreamed possible.

Yet while no two methods are identical, it soon became apparent that there were patterns in the way some of these artists approached their process. The ability to harness your unconscious is one, as in the case of Patti Smith and Bob Dylan. Sometimes it involves taking inspiration from those around you, like Lou Reed and Nan Goldin. And sometimes it's just about sheer hard work and dedication, as the examples of Martin Scorsese and Stephen King make clear. There are myriad routes to creativity, and no clear delineation between them. Creativity is both fluid and completely individual.

These pages are intended not only as an exploration of some of the greatest creative minds of today and from history, but also as chisels with which to chip away at creative block. Maybe you could make like Bowie and embrace randomness and chance: flick through the pages and take note from whichever you land on—give it a go; even if you have little interest in the person it describes, maybe you'll be inspired.

Some using this book might already have a good sense of how they work—are you a fanatical organizer, or more in tune with the mystical side of creativity? If you know you have little patience with muses, transcendence, and the like, seek out those who favor regiment and control— maybe you're a Manolo Blahnik or Alfred Hitchcock, in complete command of every aspect of their craft. Find creative catalysts in chaos? Then

you're a little like Francis Bacon, so be inspired and encouraged by his anarchic example. If you prefer to work with the twinkle of esoteric, cabalistic mysteries on the horizon, or keep one eye following sacred and ancient patterns of the universe, know that Ana Mendieta and Yayoi Kusama share your sensibilities. As Toni Morrison implores: take the time to understand the minutiae of your own process, and in doing so, you'll "open doors" to your own imagination.

For all of my own adventures into the minds of these creative heroes and heroines, it took weeks of panic, procrastination, and blank page-staring for me to even write this simple introduction, before it suddenly poured out, scribbled in good old-fashioned ballpoint in a notebook in bed at a humdrum English holiday camp. As countless thinkers throughout history have revealed, inspiration can strike at any time, anywhere, and for strange and deliciously unfathomable reasons. Like Agatha Christie and Bill Viola, for me it's notebooks that are the most fruitful tools with which to capture these elusive flashes: I wrote the first scrappy draft of this in one of three dog-eared books I carry everywhere—that might sound like a lot, but Christie was known to have anywhere up to half a dozen on her at any given moment.

While this all seems to point to the legitimacy of that good old cliché of the eureka moment arriving while you're brushing your teeth, on the bus, or in the bath, another thing that so many artists and thinkers agree on is that sure, the concept of the metaphysical "muse" is rather

lovely, but we cannot simply sit, palms outstretched, waiting for her to alight. "To know what you're going to draw, you have to begin drawing," as Picasso puts it. Nick Cave, too, acknowledges that the oft-mythologized artistic process is "just hard labor."

That groundwork and practice is likely to be sometimes rather boring. We'll suffer the ugliness of a wastepaper basket overflowing with furiously crumpled sheets of abandoned drafts; canvases will be ruefully painted over and started again; guitar strings will be broken, and fingers might bleed. But along the way, it's okay to make mistakes: Christoph Niemann's whole ethos is based around it. Sometimes, the best things arrive from the detours and the blunders. And it's okay to progress slowly—let Joseph Heller reassure you of that.

Hopefully this book will prove that while great works of art carry mysteries, the creative process itself should not be such an unfathomable and rarefied thing. It is multifarious and certainly fascinating, but it is also often rather banal. These great minds are in many ways just like yours and mine—it's a combination of graft, talent, and dogged individuality that makes these artists stand out as the visionaries they are. Learning more about these people and their often weird and wonderful ideas about how to approach creativity will, I hope, not only bring new methods to your figurative (or literal) table, but also inspire you to embrace the magic of your own process.

Björk

Björk often references her lifelong love of nature, and has always used walking outside as a springboard for writing lyrics. Even as a child, her 40-minute journey to school was spent singing and writing songs: "Going down the hill, that would be the verse, and then up the hill, that would be the chorus ... my accompaniment was nature."

Today the musician still uses similar methods, taking a rural landscape as a canvas onto which she transposes melodies and words. She loves to hike, especially in her native Iceland:

"There's something about the rhythm of walking, how, after about an hour and a half, the mind and body can't help getting in sync. I have written most of my melodies walking and I feel it is definitely one of the most helpful ways of sewing all of the different things in your life together and seeing the whole picture. I have to say, hiking in cities doesn't do the same trick for me. It has to be rural."

When she can't escape the city, Björk turns to its waterfronts and harbors as the closest thing she can get to the expansive plains of the natural world. It's not just inspiration she finds outdoors, though; non-urban spaces are also perfect for honing her distinctive voice. She credits the humidity of a rainforest climate, and that of Iceland, too, as greatly beneficial to her vocal sound.

Leonardo da Vinci

Among the touchstones of ultimate Renaissance man Leonardo da Vinci's principles was *connessione*, meaning "connection." Leonardo believed that recognizing and appreciating the interconnectedness of "all things and phenomena" was essential to understanding the world and creating within it.

He applied this theory not only to big ideas—linking numbers and patterns with art and nature—but also to the individual: he believed that the brain and body should be viewed as a single unit to nurture, and that neither could thrive without the health of the whole.

This meant that as well as being the polymath who painted the *Mona Lisa* and *The Last Supper*, drew the *Vitruvian Man,* and is credited with the invention of the parachute and the helicopter, Leonardo was also a great athlete. Not only did training in fencing, horse riding, and athletics keep him fit, but since aerobic exercise improves the flow of blood, his brain may also have been better able to process the oxygen needed for peak performance.

On the other hand, Leonardo's creative and technological fabrications were born of the same discipline required for physical activity. This principle, which Leonardo termed *corporalita*, underscored the importance of balancing body and mind, and the simultaneous cultivation of fitness and dexterity in both.

Nick Cave

If only the creative process was as simple as Nick Cave purports it to be in the pithy statement that introduces his quasi-documentary *20,000 Days on Earth*: "I wake. I write. I eat. I write. I watch TV." His method has something of that pedestrian formula to it, mixed with a little of his well-honed gothic mystique.

Cave sees everything and anything as a conduit for ideas. When he was fairly new to Britain from his native Australia, one tool he used to encourage a creative state of mind was his "weather diaries." These journals were ostensibly poetic recordings of the changeable (and largely uncongenial) British weather, but Cave's reflections grew into something more. They formed metaphors and catalysts for broader contemplations on life, death, and everything in between that would then feed into his writing.

He often turns apparently non-creative situations into sites for idea-generation: his 2013 book *The Sick Bag Song* started from writing down ideas, observations, and memories on (yes) airplane sick bags during a US album tour. At the same time, he acknowledges that the oft-mythologized artistic process is "just hard labor." Even when you think you have nothing, you have to just start writing rather than waiting for inspiration—"it's a self-perpetuating thing." The key, he says, is to be prepared before you sit down to write: have all those disparate ideas in place, whether in notebooks, journals, sick bags, or simply your mind. Most importantly, he says you must be sure to constantly flex the mind's imaginative powers. Then, once you're in the writing phase (for which Cave now prefers a typewriter), the words should come freely. "You can write really anywhere if your imagination is in good shape," he says. "It needs to be exercised."

Simple

Constricting

Comfortable

Cumbersome

Practical

Impractical

Coco
Chanel

The fashion industry was often almost entirely made up of male designers: men designing complicated, oppressive fashions for women. Heavy hats, restrictive corsets, lengthy trains, and cumbersome finery were the norm. Coco Chanel would break the mold in every sense: a woman designing for other women who put the wearer first.

A busy, practical, and visionary designer, Chanel's process began with empathy toward her sex. She looked to men's clothes, and specifically trade costumes, for inspiration, and pushed to eliminate the superfluous and uncomfortable in a shift toward user-centric fashion. Her utilitarian tunics and iconic little black dresses are each a direct result of this approach.

Chanel attributed her bravery in reconfiguring what it meant to dress women to her lack of a formal education. She worked on instinct and common sense rather than by inherited rules, and created her own unique visions. She put herself in her wearers' shoes, thinking around their practical needs, lifestyles, and habits. Her revolutionary suits were even designed with a pocket in the skirt for the stylish businesswoman to store her cigarette case.

Comfort, consistency, and timeless style were her chief priorities. "Some couturiers are really good couturiers but they change every week, and this is the reason why I've created my own style," she said. "I couldn't do it if I had to come up with something new every week, you end up creating a very ugly thing."

Francis Bacon

Francis Bacon's studio was renowned for its anarchic disarray. The space was characterized by paint-smeared walls and packed to the rafters with jumbled papers, broken furniture, books, and brushes. However, there was method in this madness: "I work much better in chaos," Bacon claimed, "I couldn't work if it was a beautifully tidy studio… Chaos for me breeds images."

The chaos of his studio was reflected in other areas of the artist's life: he was a heavy drinker partial to very late nights, and a frequent gambler. Yet even with this reputation as a bon vivant, Bacon's excesses had their place in structure: he said that he liked "working with a hangover, because my mind is crackling with energy and I think very clearly." He always began work at the first light of the morning, freeing up his afternoons to socialize in always the same venues each day, including the Colony Room in London's Soho.

His process, too, reflected these seemingly opposing impulses toward excess and routine. Bacon had no formal artistic training, claiming that art school would have only taught him techniques he didn't want to know. Instead, he developed his own process through trial and error, never making preparatory drawings, and letting his unconscious take over as far as possible as he "attacked the canvas with paint."

The artist often spoke about his creative process as one of making order out of chaos, and the works themselves are the result of an artistic control over disparate elements. The intensity of Bacon's work lies in its paradoxical sense of feeling direct, yet also the product of confusion and torment.

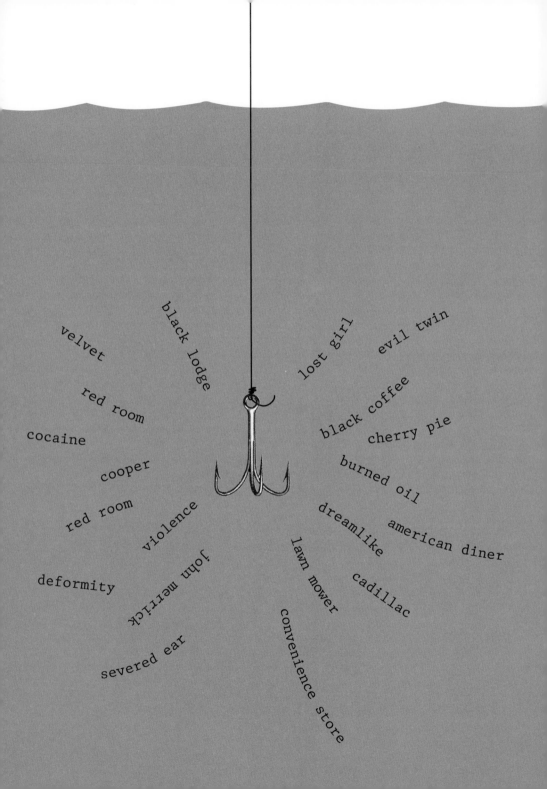

David Lynch

David Lynch compares accessing creative ideas to catching fish: we must first actively set out the bait and patiently focus on drawing them toward us. Once one idea is "caught" and written down, others begin to "swim in and join to it, and a thing will start emerging called a script." The director then begins the process of ordering these fragments into a whole, all the while keeping an eye out for "happy accidents" that align with and augment his overall vision for that particular project.

These fragments of inspiration can come from anywhere: a reflection in a puddle, the lyrics of the eponymous song that led Lynch to see a severed ear on a lawn in *Blue Velvet*, a place, daydreaming.

The director attributes his ability to receive and translate creative ideas, often coming from the subconscious, to Transcendental Meditation® which he says has allowed him to access greater levels of consciousness. "If you have a golf ball-sized consciousness, when you read a book you'll have a golf ball-sized understanding of it. But if you can expand on that consciousness, you'll have more understanding," Lynch explains. His films' sensitivity to space, color, the rhythm of dialogue, and the power of sound and music is testament to this.

The improvement to his mood that Transcendental Meditation brought about also helped Lynch's creative process. "Negative things like anger and depression and sorrow they're beautiful things in a story but they're like a poison ... to creativity," says Lynch. In turn, today he loves making art more than ever. The happier you are, the more easily creativity can flow, and so the more ideas you are able to catch.

Franz Kafka

Fighting the fretful wakefulness of insomnia is very rarely fun, but Franz Kafka transmuted his lifelong battle to sleep into something of a mystic creative tool. The frustrating vacillations between sleep and wakefulness that insomnia bring proved to be a powerful source of inspiration for Kafka, and he's said to have deliberately sought and harnessed the hallucinations and visions such a state brings, saving his writing for these wakeful hours.

Kafka organized his working day in a bizarre timetable, even when freed from the shackles of anti-social hours on being promoted to a single-shift role in his job at the Workers' Accident Insurance Institute in Prague. Despite now working from around 8am until 2.30pm, he still began writing only at around 11pm and finished around 3am.

A woozy, hypnagogic state of anxiety coexisting with dreaminess wasn't just channeled into his process, but informed plots of his stories too: Kafka's 1915 novella *The Metamorphosis* sees its protagonist Gregor transform into a cockroach after a sleepless and fitful night.

At night—or, as Kafka called it, "my old enemy"—was when his best ideas emerged. He wrote to fellow Czech writer Milena Jesenská that when he didn't write at night, he could get "a few hours of shallow sleep" yet was "merely tired, sad, heavy."

Sylvia Plath

Sylvia Plath followed strict daily routines. She and her husband Ted Hughes divided the day into set portions for writing and work: according to letters, before they had children they both aimed to write for six hours each day, from 8.30am until midday, then from 4pm until 6pm. Once they had a family the workday was divided between them, with Plath writing from 9am until lunchtime, and Hughes between lunch and teatime.

Within her rigorous regimens, Plath was disciplined about noting moments from daily life as a record of her thoughts and musings. She took great pleasure from this compulsive journaling throughout her short life, with records of her writings from the age of 12 until her death, aged 30, in 1963, and running to over a thousand pages.

Many of these journal entries would inform Plath's stories, though her poems were never explicitly sketched out in journals. Her notebooks were used, rather, to hone her craft, and they reveal some beautiful and powerful phrases relating to her everyday life, and her feelings of being an outsider. As an undergraduate in the 1950s, she discusses her sense that she should "whittle my square edges to fit a round hole"; at the end of that decade she records her decision that she should be true to her "own weirdnesses."

Pina Bausch

German choreographer Pina Bausch was known for creating raw, intensely emotional productions. For Bausch, dance was a way to not only communicate, but to experience the world. She claimed that as a child she loved to dance because she was scared to speak: "When I was moving I could feel." Her choreography was not only self-reflective and self-expressive, however; it was the product of a chorus of narratives offered by her company.

Her infamous troupe, the Tanztheater Wuppertal company, explored complex notions around the human condition using a variety of exercises, including improvisation and through direct, sometimes brutal, questioning. Bausch would ask about her dancers' parents, childhoods, responses to certain situations, likes and dislikes, hopes, and dreams. She asked them, "What are we longing for? Where does all this yearning come from?" and allowed and indeed encouraged them to be sad and furious; to cry, laugh, and scream.

Bausch believed in making work through collaboration, allowing each performer to arrive at his or her own deeply personal responses to the themes of each piece, rather than forging on alone in the solipsistic tunnel vision tempting for creatives. The answers and ideas generated in the intimate discussions between Bausch and her performers would inform her choreography; from the scene structures to gestures and the dialogue.

Though sometimes seen as cruel, Bausch was loved by her performers and inspired great loyalty. Ultimately it was Bausch's demanding and unflinching engagement with her dancers that underscored the company's capacity to bring a potent, visceral performance to the stage.

Agatha Christie

Agatha Christie's mysteries are woven from a detective-like scrutiny of the people and places she encountered in her everyday life, which were reconfigured into the characters and plots of her stories with the help of the countless notebooks she recorded them in. Christie claimed usually to have half a dozen notebooks on hand, and these were filled with anything from plot twists conjured up from her imagination to notes about "some poison or drug" she'd heard about, to "a clever little bit of swindling that I had read about in the paper."

These books were carried with her always, allowing her to jot down anything that came to her on the go. Christie was aware that plots could arrive at the most unexpected moments, such as in a hat shop, or when overhearing a conversation in a tea room. The author never had a space or room devoted to writing, and notebooks suited her itinerant way of gathering ideas and narratives as she went, always working on at least two novels at any one time.

Her notebooks were used as *aides-mémoires* rather than directly as sketches for stories or passages, and were packed with erratic musings and jolts of inspiration that sometimes went nowhere, while others might make their way directly into her final works. Once a plot was scribbled down, even in the most unformed and scrappy way, Christie could then fill in the gaps as characters gradually emerged from her thoughts, and practical narrative elements would be added in later as Christie simultaneously created and solved her fictive crimes.

Toni Morrison

When author Toni Morrison first started writing before dawn, it was because that was the only time she could be alone before her children awoke. Necessity became habit, and later became choice: she realized she was clearer-headed and more confident in the mornings, and "got dumber and dumber" as the day wore on.

Throughout her career, Morrison has always been mindful of what works and doesn't for her as an individual. She takes time to consider the minutiae of her own process, while always striving to "expand articulation" of her moral and political beliefs with her writing and "open doors" to her own imagination.

Morrison's rigorous engagement with the world around her enables her to "make contact" with the creative process. When teaching at Princeton, Morrison made a point of telling her students to undergo a similar process of self-examination to find out in what situations they were at their best creatively. She encouraged them to ask themselves what their ideal room or desk was like, the sounds, whether there was calm or chaos outside: ultimately, "What do I need in order to release my imagination?"

The other side to this formula is about being prepared, and taking advantage of opportunities. Much of Morrison's life has been taken up by family life and day jobs, forcing her to draft work on scraps of paper or whatever is to hand when inspiration strikes away from her ideal creative situation: subway journeys, for example, might be spent thinking about characters or trying to crack a problem.

Wolfgang Amadeus Mozart

There's a myth that Mozart had the ability to find himself with a complete, original composition in his mind, seemingly out of nothing. It's a tale propagated both by Mozart himself, and those who've written books or made films about him since. "...Thoughts crowd into my mind as easily as you could wish... Those which please me, I keep in my head and hum them," Mozart claimed. According to the composer, these initial ideas were then felicitously joined by another melody "linking itself to the first one," and so on for the parts of various instruments and sonic counterpoints that would make up the entire piece.

However, this wasn't the whole story. Rather than being a passive recipient of melodies, Mozart was constantly thinking about, experimenting with, and studying music. When creating compositions, he first tried out his ideas on a piano before writing the outlines of the basic first fragments of a piece. Later, aspects such as the melody and bass lines would be added, sometimes leaving space for harmonies and other additions that would be filled in at another time.

While Mozart allowed for some freedom in his collection and collation of the various compositional elements, he was also meticulous. He would jot down his initial ideas before working out the most important parts of each piece and finally putting the entire composition into writing. The composer's creations were gradually improved over time, working to a far more strict routine than he admitted. "One doesn't believe the gossip at all, according to which he [Mozart] tossed off his significant works swiftly and hurriedly," biographer Georg Nikolaus Nissen claimed.

Andy Warhol

Andy Warhol's legacy is one of scandalous stories and myths from his famous New York studio, the Factory—as you might expect from the man who made being an artist analogous to being a film or pop star. He surrounded himself with the crazy and the beautiful, with an open-door policy to those pretty young things he found to be fascinating and inspiring.

These artists, models, sex workers, waifs, and strays became the actors in his films and the subjects of his Screen Test silent film portraits, as well as his screen-printed works. While some companions served as his beautiful and magnetic muses, like Edie Sedgwick and Nico, many became his assistants or documentarians. Billy Name, for instance, acted as the artist's photographer, all-round handyman, studio manager, lover, and pretty much everything else.

Aside from directly helping to make works, record them, or star in them, this cast of characters served another equally vital but less tangible role: they validated and reassured the famously insecure Warhol. According to Stephen Shore, who began photographing the Factory in 1965 when he was 17, the artist would always ask those around him for their opinions. "My guess is that it helped him in his work to have people around, to have these other activities around him," says Shore. "I think he kept people involved by asking, 'What do you think of this? Oh, I don't know what color to use. What color should I use?' Just something to keep the swirl of activity around him."

Charles Dickens

Charles Dickens's writing demonstrates a keen and thorough sense of the world around him which could be attributed to his devotion to long walks: the writer is said to have averaged almost 20km (12 miles) on any given day. Known to be a whirlwind of energy, it was only in this contemplative and solitary activity that Dickens could shift his mind to a state where creative thought could flourish.

Through his work as a journalist, editor, and social reform campaigner, Dickens sought to highlight the plights of the poor and encourage a more charitable society. His journeys on foot through London's more insalubrious streets brought him closer to the issues he was exploring and gave him the insights he needed for such work—as well as material for his richly detailed novels.

Not only did walking allow Dickens to truly understand the places and the people who inhabited his works, it also enabled him to "hear the voices" that helped him in his writing. Rather than actively creating situations or characters, he claimed he instead recorded things he saw around him and heard internally. "When I sit down to my book, some beneficent power shows it all to me... I don't invent it—really do not—but see it, and write it down," Dickens wrote in a letter to his friend John Forster.

Of course there was one episode in which walking became the literal inspiration for a scene: one evening in 1857 Dickens walked almost 50km (30 miles) from his home in central London to his house in Kent, probably to escape his domestic situation when his marriage was struggling. In *Great Expectations*, we see Pip undertake a very similar journey, albeit in the other direction.

Yayoi
Kusama

Since childhood, Yayoi Kusama has used art as a way to deal with trauma and her well-documented obsessive-compulsive disorder. Kusama's drive to make art has manifested most strongly through her mode of repeating particular motifs ad infinitum: polka dots abound, as do phalluses, and her famous "infinity" mirrors riff off repetition of repetition.

One of her first ventures into repetition as medium was 1959's *No. F*, the first in her Infinity Net series. She covered an entire canvas in tiny dots built up through many layers of paint to create a "multiverse" of circles upon circles. In 1962's *Accumulation No.1*, the artist turned an armchair into a surreally sexualized object, painting it white and totally enveloping it in numerous soft phallus-like protrusions. In doing so, she both developed an entirely new and very personal mode of making work, and concurrently confronted her own fears around sexuality.

Through repeating certain images or symbols, Kusama creates aesthetically striking pieces while also striving to negate the fright-ening things they represent to her. She has said that the polka dots, for instance, symbolize disease, while her Infinity Net paintings represent her horror at realizing the "infinity of the universe." Repetition becomes a multitude of things: beauty, play, symbolism, artistic medium, expression, and therapy. "My artwork is an expression of my life, particularly of my mental disease," Kusama has said.

41

Grace Jones

The formidable Grace Jones has long lived by the maxim "try everything at least once. If you like it, keep trying it." This has included a variety of drugs, modeling, clubs, hairstyles, and men. Jones's powerful determination ensured that even though she knew she didn't have the best voice, she was undeterred in pursuing her goal to become a singer. And even when she was a wild, high, party animal, she never lost control of herself.

Her confident, experimental outlook also means Jones has never been afraid to simply move on to a new place or a new career avenue if the one she's at isn't getting her where she wants to be. To live the life of a true artist, she says, "you must always be traveling to new places and moving around." That way, you're constantly engaging with what's going on in the world around you; taking in what's been done already so you don't repeat it, and showing your own take on it through your art.

So it was that Jones moved from her birthplace in Jamaica to New York when she was 13 years old, beginning her modeling career and soon becoming a fixture on the burgeoning disco scene. Yet by the time she was 18 Jones felt the city was "blocking" her—so she simply moved on, traveling to Paris, where her modeling career took off, and where, within just a few months, she signed a record deal and began recording music, achieving her goal.

Alfred Hitchcock

Alfred Hitchcock's prowess in his craft is the result of a tireless, obsessive work ethic inspired by his working-class roots. His pictures include *Vertigo*, *Psycho*, and *Rear Window*, each a pillar in the cinematic canon. Such a prestigious oeuvre was achievable only through his dedicated comprehension of every step in the filmmaking process.

For Hitchcock, hard work meant mastering every discipline from screenwriting to sound and set design (as well as acting in his famous cameos); and poring over every visual, dialogical, and sensual aspect of his films. "As a craftsman, Hitchcock was, indeed, unparalleled, so well acquainted with his tools that he never had to look into the camera, because he always knew how any given shot would come out," wrote Mark Crispin Miller in his obituary of the filmmaker.

Throughout his vast 53-year career, Hitchcock was as controlling of his medium as he was of the seductive blonde actresses (like Tippi Hedren) with whom he was infatuated, and he famously held his crew to impossible standards. There are many tales about how he drove his writers to insanity with constant interlocutions and meddling in their roles. He claimed to have written most of the scripted dialogue in his films himself, though his name appears as a writer's credit only on *Dial M for Murder*. And he never, ever improvised—either a blessing or a curse for actors, depending on their temperaments.

Manolo Blahnik

Manolo Blahnik built his vast shoe empire with no formal training: instead, he went to art school, studying architecture and literature in Geneva and at the École des Beaux-Arts in Paris. He learned his craft from the factories, speaking with pattern designers and fabricators to better understand the process, and even trying on the shoes he made to ensure they were comfortable.

Although he doesn't believe in a "creative process" as such, Blahnik works by creating an imaginary woman in his head and designing shoes for and around her. Indeed, he attributes much of his success to the women who inspired and encouraged him when he was starting out: Bianca Jagger, Paloma Picasso, and Marisa Berenson all were "mad about" what he was doing.

Now in his 70s, he still retains complete control of all aspects of his eponymous brand. Every shoe is personally designed by Blahnik, and he even hand-carves the wooden forms they're produced from. He has never employed an assistant and to this day doesn't have a team around him. This obsessive approach seems natural for Blahnik, serving his passion for perfection: "I like to finish the product beautifully, with the best materials, the perfect balance in a heel, and do the best I can."

The control he exerts over his work is reflected in his private life: Blahnik claims to never have personal relationships, saying, "I don't fall in love with people, I fall in love with art." He rarely sleeps for longer than five hours each night, instead using that time to draw shoes. But for the designer, control and independence mean freedom: "It's the only luxury I have. I choose what I want to do."

47

Lou
Reed

From junkies and prostitutes to cross-dressers, models, and the young, beautiful, and troubled—Lou Reed had a way of telling stories through his songs that transports both the listener and the teller into the shoes of their stars.

His background as an English major at Syracuse University undoubtedly gave Reed his foundation as a storyteller, but the experiences he sought out provided the stories themselves. New York's Lower East Side rock 'n' roll scene and those drugged-up, transgressive, and fascinating characters who populated it gave Reed his unique aesthetic. He was creating tales of the people and subjects most musicians shied away from in the 1960s—kink, homosexuality, drugs, mental health, and failure. "I wanted to write songs that related to real life as opposed to all the shit that was out there," he said. He didn't just sing about feeling "sick and dirty, more dead than alive" while waiting for his dealer ("my man"), he actually lived it.

A keen and perceptive observer, Reed was open about the importance of the lessons he learned from those around him, such as in Warhol's Factory where he'd sit watching "these incredibly talented and creative people who were continually making art, and it was impossible not to be affected by that." He walked among the speed freaks, junkies, and artists and was all of those things too, hence the perceptible empathy with those sweet, damaged characters immortalized in his songs.

Marina Abramović

Few artists have taken such risks with their lives for art as Marina Abramović has in making her deeply powerful, often intensely personal, and occasionally enormously painful challenges for both the viewer and herself. In 1974's *Rhythm 5* she passed out through lack of oxygen while laying in the center of a burning star, while in 2010's seminal MoMA show, *The Artist is Present*, Abramović sat in a chair in the middle of the gallery space, silent and staring, while audience members took turns to sit opposite her for as long as they wished. While this doesn't sound too hard for a few minutes or hours, Abramović performed this piece every day for three months.

Over the four decades she's been making work, the artist has developed ways to train her mind and body to perform these punishing works of art. The Abramović Method, as it's known, involves exercises based on breathing, motion, stillness, and concentration. Examples include counting grains of rice for six hours, writing out your name as slowly as possible, and walking very slowly with repetitive gestures.

The aim of all these exercises is to achieve clarity of mind (and potentially, transcendence from pain) through stillness, silence, simplicity, and the utmost focus on the task in hand: being utterly present in the moment and in the self. For Abramovic´, the artist must be "a warrior"; they must first conquer themselves to make great art, and, in doing so, empty themselves to put their mind in the "here and now." Actions must be experienced, not merely considered or externally observed.

Tennessee Williams

Consciously or not, playwright Tennessee Williams was driven to exorcise his demons through writing. "I was a born writer, I think," he said of being ill and bedridden for six months aged eight: after this illness he no longer played with others, instead beginning "an intensely imaginative life."

The emotional realism that is present in Williams's work is largely thanks to his ability to draw on the painful aspects of his own life: a tyrannical father, an unstable mother, his childhood illness, his at times crippling shyness, initially suppressed homosexuality, and, perhaps more than anything else, his beloved sister Rose's mental health issues. Rose was schizophrenic, and underwent a prefrontal lobotomy authorized by their mother in 1943. From then on she spent most of her life in mental institutions, and became her doting brother's unlikely muse.

Many of his plays have characters and themes that can be traced to Rose: Laura in *The Glass Menagerie* is dubbed "Blue Roses"; in *Suddenly, Last Summer* elderly Mrs. Venable requests that her niece have a lobotomy; while Blanche DuBois in *A Streetcar Named Desire* becomes increasingly unstable before finally being institutionalized.

Through the transformative power of imagination, Williams was able to take hold of the difficult, tragic, and purely inexpressible experiences in his life and weave them into art, thereby creating works that are not only realistic but also poetically resonant. "I don't think that anything that occurs in life should be omitted from art," he said, with the caveat that these occurrences should be presented in a way that "is artistic and not ugly."

Georgia
O'Keeffe

While Georgia O'Keeffe's work depicts the wonders of the natural world, documenting its expansive plains and mountains or its exquisite flora, her process of painting was born from a meticulous way of harnessing inspiration.

She spent much of her time outdoors creating photographs and drawings, or collecting artifacts like rocks, bones, and flowers to take home. She would place them together in various configurations and draw or paint them over and over again, moving from literal depictions to more abstracted forms that took on a whole new life. A shell or piece of shingle, for instance, could morph into representational dark and light shapes or spaces.

Every drawing she made was placed in a named folder and every object she collected was photographed from various angles in different lights, and her paintbrushes were looked after with equal care. She systematically arranged what inspired her and studied every nuance of her subjects' forms. Such intense engagement with her materials and the process of painting itself—often performed in silent seclusion—were crucial to O'Keeffe's vision. Her images often present one dominant object that commands the viewer's full attention, just as it demanded hers.

For the artist, organization allowed for greater freedom of expression in the art itself, which imbued real physical subjects with ideas around life, death, illness, and identity through her creative imagination. Drawing on hours spent walking in the natural world, documenting it and recording it, she was able to transcend its physicality and portray, as she put it, "the unexplainable thing in nature."

GO TO THE PUB

Mark E. Smith

For all his heavy drinking, well-documented amphetamine habit, cruel tongue, and propensity for fist fights, Mark E. Smith had fine literary pedigree. His band The Fall was named after the novel by Albert Camus, and he's spoken of a love for Aldous Huxley, Kurt Vonnegut, and Henry Miller, alongside other great novelists and poets. His long reading list makes sense when you consider the strangely poetic nature of his lyrics, or his song and album names—surely only a voracious reader could come up with titles like *Hex Enduction Hour*, *Bingo Master's Breakout*, and *How I Wrote "Elastic" Man*.

But it's not the fact he spent a lot of time in libraries that Smith attributed to feeding his prolific songwriting, but his drinking habits. Specifically, he saw his writing as a product of going to the pub. In 1983, he dictated a six-day guide to writing as part of a show on Greenwich Sound Radio, which he dubbed the "Mark E. Smith 'Guide to Writing' Guide."

Apart from day one—"Hang around house all day writing bits of useless information on bits of paper"—each day involves a trip to the pub. On the second day, the writer decides his lack of inspiration is "due to too much isolation and nonfraternization." So, "Go to pub. Have drinks." The final four days go like this: "Day Three: Get up and go to pub. Hold on in there as style is on its way. Through sheer boredom and drunkenness, talk to people in pub. Day Four: By now people in the pub should be continually getting on your nerves. Write things about them on backs of beer mats. Day Five: Go to pub. This is where true penmanship stamina comes into its own as by now guilt, drunkenness, the people in the pub, and the fact you're one of them should combine to enable you to write out of sheer vexation... Day Six: If possible, stay home. And write. If not, go to pub."

Henri Matisse

The vast, bold paper cutouts for which Henri Matisse is best known were the product of a method borne of necessity. Despite this, they proved to be the pieces that gave him a new lease of life artistically, and have inspired generations of artists since.

Matisse had initially dabbled in cutouts in the early 1930s during preparations for a mural he had been commissioned to create, but it wasn't until many years later that the medium became his primary form of expression. In 1941 he was diagnosed with cancer, which left him confined to a wheelchair for his final 14 years. Rather than falling into despondency and giving up his work, Matisse heralded this period his *seconde vie* (second life): his illness catalyzed an exciting, vibrant new way of creating that he wouldn't have discovered without it. Indeed, the pieces he created in these years are bursting with joy and vitality.

From his chair, Matisse used scissors to make paper shapes freehand, which were pinned to walls and gradually formulated into final compositions with the help of a troupe of studio assistants. The artist dubbed this process "painting with scissors," and claimed it renewed his sensibility for color and composition. "I see it as a simplification," he said of his 1940s Jazz cutouts series. "Instead of drawing the contour and putting color into it—one modifying the other—I draw directly in color."

Patti
Smith

Patti Smith has a wonderful tale about how a song once arrived in her mind "fully formed." She was standing alone in her living room when suddenly she had a vision of The Grateful Dead's Jerry Garcia smiling at her. "And then this little song—poof!—came," she says. She called the resulting song "Grateful," "as I felt Jerry had given it to me."

Smith underscores the importance of keeping your mind and spirit open to such abstract bursts of creativity in what she describes as a "channeling" or "shamanistic ability." But despite these fortuitous moments of inspiration, Smith admits that writing is very rarely this easy: it's a task that requires being taken seriously.

In essence, she works hard to ensure her focus is sharp enough and her mind open enough to perceive the messages that come from intangible places—whether that's channeling the spirits of dead poets like her beloved Rimbaud, invoking esoteric forces, or being receptive to signals from the unconscious—in a way that's constructive to her art. Dreams, reminiscences, images, emotions, literary fragments, and political commentaries all intermingle in Smith's writing, discovered through openness and diligence, assembled through a process that lets them fall into place naturally, and then carefully whittled into their final forms. In her words, "Most often, the alchemy that produces a poem or work of fiction is hidden in the work itself, if not embedded in the coil and reaches of the mind."

Zaha Hadid

Staunch Modernist Zaha Hadid had an uncompromising attitude to her art and life that meant that she never lost sight of her creative vision. Whether designing buildings, interiors, furniture, or homeware pieces, Hadid's futuristic forms were not subject to trends—or, necessarily, budgets and timeframes: her 2012 London Olympics aquatic center famously cost three times the original estimate, and was the first Olympic building begun and the last to be finished.

Seen as tough and intimidating, Hadid required this steely resolve to break through what she calls "the boys' club," which she sees as not only a feature of the world of architecture, but of the world in general. And Hadid was a woman who stuck to her guns. She knew she wanted to be an architect from when she was 11 years old, and forged her own path "through perseverance and hard work" with the double challenge of being not only a woman but also a "foreigner." An Iraqi-born woman in a misogynistic industry dominated by white men, it took this level of determination to become one the most successful architects in the world: "I never took no for an answer. I never sat back and said 'walk all over me, it's okay.'"

The creative life is full of challenges ranging from simple mental blocks to full-on cultural ones. If Hadid's example teaches us one thing, it's the value of hard work and stubborn persistence.

You've got to allow yourself to make a lot of mistakes. Then the real magic will happen. If you just play it really safe, you won't get any treats.

— Bjork

Edgar Allan Poe

In 1846, Edgar Allen Poe set out his startlingly logical methodology for creating a poem in the essay, "The Philosophy of Composition." In a stark counterpoint to the spontaneous, almost divine creative methods espoused by the likes of William Wordsworth and Samuel Taylor Coleridge, Poe stated that writing poetry should adhere to certain rules in order to be truly powerful.

e

nevermore

nevermore

The most important of these was what he termed "unity of effect": first, the writer must decide on which of the "innumerable effects, or impressions, of which the heart, the intellect, or (more generally) the soul is susceptible" they want to communicate. Only once this effect (and, crucially, the denouement in which it culminates) has been selected do the seemingly more obvious building blocks—such as narrative, theme, characters, and tone—come into play. By working backward from the end and the effect, each other component will feel natural and compelling in driving the plot and emotional resonance toward their conclusion.

Poe presents a cool, critical detachment in discussing his masterpiece *The Raven* according to these doctrines—so much so that a few critics since, most notably T. S. Eliot, have wondered if the essay was written as satire. Poe explains how certain words, such as "nevermore" and "Lenore" were selected not for their movement of plot or theme, but for their sound. The long, sonorous vowels of these words capture the particular emotion he had set out to achieve. As such, the refrain of "nevermore" constantly jolts the reader back to "melancholy," which—along with beauty—Poe had chosen as the "effect" of this piece, calling it "the most legitimate of all the poetical tones."

Gertrude Stein

In *Everybody's Autobiography*, Gertrude Stein revealed that she was only ever able to write for about 30 minutes each day, but pointed out that over a year, those half hours begin to add up. However, this was caveated with the lamentation that every day (after getting up "as late as possible") was spent "waiting around to write that half hour."

While half an hour seems like a remarkably small stint, the rest of Stein's day was often spent in activity that provided the fuel for her writing so that the short time was used powerfully. She relied on her partner Alice B. Toklas to manage her life, to take care of everyday tasks, and act as her reader, typist, and critic. Toklas also accompanied Stein, who preferred to write outdoors, on her frequent excursions into the country to sit and take in the landscape. Sometimes Stein would fix her gaze on something like a cow or a rock, and if nothing in her sightline proved interesting or inspirational, the couple would drive elsewhere.

Stein's advice for making those little half-hour windows of time count was to consider writing as a process of discovery, rather than entering into the creative process with an end result in mind. The act of creation, she said, must take place "between the pen and the paper," not in premeditated planning or a "recasting" afterward.

Martin Scorsese

Martin Scorsese is renowned for being a passionate cinephile. From a very young age he's been obsessed with the history of movies and the minutiae of making them: at the age of eight, he'd already begun sketching out frame-by-frame recreations of the films he was watching. According to Leonardo DiCaprio, who has worked with Scorsese numerous times, the director would wake up in the middle of the night remembering a scene or image from an obscure film, and immediately get up to screen it.

Such devotion to his medium has fostered in Scorsese an encyclopaedic knowledge of how to tell a story visually and get the best out of his actors. It's also meant a thorough working knowledge of filmmaking conventions, which he employs more than you might expect. He often uses freeze-frames, slow motion, and flash guns, for instance; and if he wants to show you that someone's holding a gun, he'll simply cut to a close up of one in their hand. He's never afraid to delve into the archives to figure out (and to show his cast and crew) how he wants to approach a scene or a whole film. For *Goodfellas*, he borrowed characters and musical decisions, among other things, from 1931's classic gangster movie *The Public Enemy*.

Now well into his 70s, Scorsese's passion, work ethic, and reverence for cinema history show no sign of waning: every interview sees the director wax lyrical about certain directors, shots, and images he adores and has consigned to memory. Through these, he understands how to make his own films into those that'll be remembered in the same way.

Kate Bush

The mesmerizing thing about Kate Bush's work is that unlike most other pop stars, the woman writing and performing these extraordinary songs is a total enigma. In trying to decipher her literary, topical, or folkloric reference points, you learn nothing of Bush herself—but so much about the power of imagination and empathy in creating unforgettable tales.

A shapeshifter of an artist, Bush frequently writes from the perspective of another. The most obvious example is "Wuthering Heights," and its unforgettable chorus, "Heathcliff, it's me Cathy!" written from the perspective of the character Cathy Earnshaw from Emily Brönte's novel of the same title. "Army Dreamers" sees Bush embody a mother grieving for her soldier son, plagued with guilt at his death during military maneuvers. In an even bigger leap of the imagination, "Breathing" is about a fetus troubled by the potential of nuclear fallout.

Bush's creation of all these characters shows a willingness to sublimate her own identity in favor of channeling another's feelings, drawing on anything from novels, films, paintings, or simply half-remembered stories from television—as in the case of her tale of a wife's jealousy in "Babooshka." The costumes and choreography that accompany a song are essential to the process: "Once the song has been written, whoever is singing that song isn't necessarily me—it becomes the character."

THIS IS
NOW

Wolfgang Tillmans

German artist and photographer Wolfgang Tillmans's oeuvre comprises work that feels utterly instantaneous, taking the snapshot aesthetic to create statements about finding bigger meaning in seemingly inconsequential moments and objects.

He has always worked from a standpoint of being in the here and now. Early on in his career in 1988 he was entrenched in the acid house and techno club culture of Hamburg—an "all-encompassing" and wildly exciting experience that he felt compelled to communicate. He bought a $15 flash and began photographing clubbers and club scenes. Tillmans sent the results into *i-D* magazine, and his photographs were published. "It was this very immediate thing," he says, "I wanted to capture how amazing the scene was."

This air of spontaneity permeates even his carefully constructed fashion shoots, as well as the still lifes that seem like nonchalant records of banal moments—the stain of watermelon on a clean white plate, or the view from an airplane window. Tillmans embraces the role of chance in making work, so that even when meticulously arranging his objects for an installation to shoot or corralling his subjects, his results are often unexpected and feel liberated from overt staging and artifice. Not only does this make the quotidian fresh and exciting, it also imbues each image with a sense of intimacy.

For Tillmans, the joy of photography is that in the instant that you press the shutter, even the most familiar scenes, people, and experiences are seen afresh: "in that second it is all active." He lets the subconscious mind take over and embrace a single moment to make an image. "Many artists try to predict what will look good forever," he says. "It's impossible. There is only the here and now."

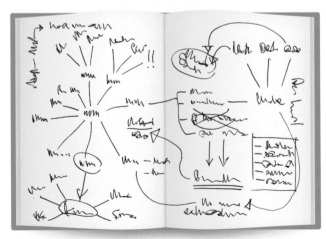

Bill
Viola

Since his days at Syracuse University, artist Bill Viola, known for his works in digital media and video, has always worked according to a distinctly analog process. This involves three separate types of notepad, dubbed his Notebooks, Project Books, and Working Books. To this day, he follows the same regime, using each at different stages from the seed of an idea or a reference point to the final technical realization of a piece.

The Notebooks are like quotidian journals in which he jots down ideas: fragments from other artworks, literature, religious texts; or simply musings, occurrences, or memories that inspire him. These books could show diagrams, sketches, or passages of text—sometimes quotations from writers and thinkers, sometimes his own creative writing, sometimes observational notations. Writing is a crucial part of his work, as Viola rigorously interrogates and intellectually engages with philosophies and aesthetics from throughout the history of art, and it's here that you can see certain themes in his visual output emerge, such as his frequent metaphor of water as an expression of spirituality, and varying states of mind.

When he feels one or a combination of ideas is promising enough to carry into a fully fledged artwork, he moves into a Project Book. While Notebooks are more generalized gatherings of ideas, each Project Book is dedicated to a particular work and it's here that Viola more fully immerses himself in how to express his concept visually and physically. Once these are thrashed out to a place where he's ready to make the piece, Viola moves on to a Working Book. These are intricate, technical documents that specify exactly how that piece will be produced. They include shot lists, storyboards, costume ideas, and even hand-drawn editing timelines.

Pablo Picasso

Pablo Picasso's 78-year career produced work that was unwavering not only in terms of the skill and originality of its execution, but also in the consistency with which it was produced. Throughout his life Picasso created more than 13,500 paintings, 100,000 prints and engravings, and 34,000 illustrations. It seems the artist rarely suffered anything resembling creative block; a testament to the fact that he didn't see ideas as abstract entities to be sought out or patiently waited for, but as the natural products of just getting on with the work.

"Ideas are simply starting points," he said. "As soon as I start to work, others well up in my pen. To know what you're going to draw, you have to begin drawing."

Picasso was known to be supremely confident, and this accounts for his fearlessness in trying new materials, media, and styles. He shifted from direct representations of the world to Cubist depictions of scenes that were more about feeling than reality, to abstraction, to playful sculptural pieces, not only between the distinct "periods" of his career but often simultaneously.

His restlessness and determination to constantly evolve as an artist demonstrate his joyfully unconstrained approach: he saw action rather than meticulous planning as the foundation of a successful artistic career. That's not to say he didn't plan his pieces and wasn't a perfectionist—he often painted over the same canvas two or three times if he felt the work wasn't going where he'd hoped. But he wasn't one to linger and wait for a muse to strike: he worked constantly, and in doing so forged new paths that have shaped the very nature of contemporary art since.

Oscar Wilde

Oscar Wilde's writing is full of witty epithets about creativity, making artistic sensibility sound at once simple and out of reach, the rare product of a special mind: "Consistency is the last refuge of the unimaginative," for instance, or, "A writer is someone who has taught his mind to misbehave."

The mischievous pleasure evoked in such aphorisms underscores Wilde's views of what it means to be a writer. "Work" should be seen as an urge and a pleasure, rather than an onerous chore and a necessity to make ends meet. "Work never seems to me as a reality, but a way of getting rid of reality," he wrote to his friend, the poet W. E. Henley. For Wilde, art was a way of elevating day-to-day realities into something more beautiful.

Wilde's work also provided a way of making his frequently tumultuous personal life more comprehensible and palatable, allowing him to approach it through the prism of his aesthetic ideal. He wrote to his lover Lord Alfred Douglas that his art was "the great primal note by which I had revealed, first myself to myself, and then myself to the world" as well as being his life's true passion—"the love to which all other loves were as marshwater to red wine."

Indeed, Wilde seemed to view his very existence in terms of art: through his dress, his surroundings, his relationships, and his social engagements he strove for finesse and beauty. When these were unavailable, Wilde was no less devoted to his art. Wilde's heartbreaking epistolary essay *De Profundis*, written during his imprisonment in Reading Gaol, reframes his fall from grace as a tragic turn in the dramatic narrative of his own life.

Christoph Niemann

New Yorker illustrator Christoph Niemann's delightfully clever visual puns often appear so simple that it could be easy to dismiss the work that goes into them. In his Sunday Sketch series, for example, he sat down each week and took an object—for instance, a coin, an ink pot, pencil shavings—added a few brushstrokes around them, and transformed them into a scoop of ice-cream, a camera, and a broken flower, respectively.

That the detritus scattered throughout Niemann's Berlin apartment can be as much a part of his toolbox as his inks and brushes is thanks to his talent for seeing the visual possibilities in the commonplace—a talent honed by a great deal of work.

Niemann says he sketches "all the time," and it's only through constantly drawing that he arrives at the kernel of a great idea. Crucially, he rarely gives up on an image, even if it seems it isn't working: often he'll create an image a few times, consider it to be "terrible," put it aside, and then go back the following day and see the strength in it. Mistakes are nurtured, rather than rejected.

The most important thing in the creative process, according to Niemann, is to avoid shortcuts, and to never be thinking about how you can make creating "faster or better." Essentially, it all comes down to hard work, putting in the hours, and a great number of scrunched-up killed sketches |to make something look like it was effortless.

Wes Anderson

Wes Anderson is known for creating intricate worlds in his films, characterized by striking color palettes and meticulously orchestrated wide-angled shots. Every last element of the set—whether in or out of shot—corresponding to the director's precise vision.

Such vivid cinematic universes are crafted through a mix of research, script and character development, and planning. Google Earth was used to initially scout locations for *Moonrise Kingdom*, slowly narrowing in on the perfect places, which then, in turn, inspired the details. In preparation for *The Darjeeling Limited*—a film about three brothers quarreling their way through a pilgrimage across India—Anderson toured Rajasthan by train, essentially pre-enacting the brothers' journey with co-writers Jason Schwartzman and Roman Coppola. The experiences and references discovered through research are all brought into play in the creation of each film.

The director then translates his broader visions to the screen with superlative attention to detail. His obsessive approach is revealed through the tales of *Moonrise Kingdom*'s graphic designer, Annie Atkins, who has said that 30 or 40 copies of each prop were made by hand to ensure there were enough to withstand the potential number of takes that might be shot. Even props barely seen on screen for a couple of seconds are given the utmost consideration: the postage stamps in *The Grand Budapest Hotel* are barely visible, but an illustrator was commissioned especially to create them.

All these exactingly fabricated pieces of ephemera and the intense pre-production planning are what ultimately make Wes Anderson's visions so compelling, elevating his films from lush fantasies to strangely convincing worlds.

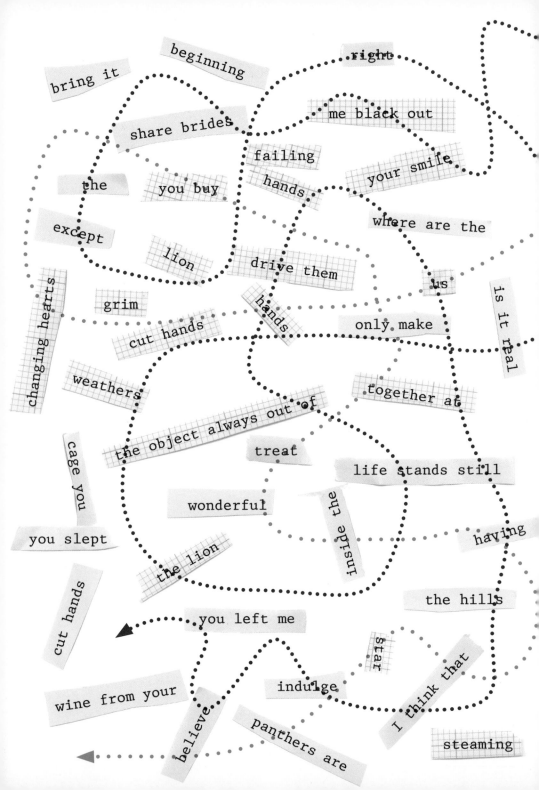

David Bowie

A musical chameleon with 25 studio albums, nine live albums, 49 compilation albums, three soundtracks, eight EPs, and 121 singles, David Bowie constantly reinvented both himself and his sound. But a few things remained fairly constant in the way he worked throughout his career, one of them being the cut-up technique to initiate ideas.

The invention of this method has been traced back to the Dada art movement in the 1920s, but came to prominence thanks to writer William Burroughs in the 1950s and 1960s. In Bowie's version, he took words or phrases from various sources including newspapers and hand-written sentences, physically spliced them, mixed them together (sometimes in a hat), and then pulled out the fragments, rearranging them into new configurations. The products of his discovery of inspiration through randomness can be seen on some of Bowie's finest albums including the late 1970s Berlin trilogy of *Low*, *Heroes*, and *Lodger*.

In the 1990s, he used a digital version of the cut-up technique, dubbed the Verbasizer. Here, a piece of Mac software allowed him to input sentences into columns labeled with descriptors like "nouns" or "verbs." The program would then mix up the words from across the rows and columns to create new phrases, which would often spark off new ideas for lyrics and themes: "Even four words might be enough to send me off on a song," he said.

To maximize the power of juxtaposition to inspire, Bowie left less to chance. In a 1997 interview, Bowie spoke of the power of getting up at 6am: "There's something I find very optimistic and creative about working and being in the daylight."

87

Ana Mendieta

Cuban-born artist Ana Mendieta made her "earth-body" art using her body and the natural world—trees, mud, rocks, blood—as her canvases, brushes, paints, and backdrops. Her creative ethos centered around her philosophy of re-establishing the ties between her own body, nature, and the universe: she was performing the process of making these connections.

The driving force behind her artistic purpose can be traced back to her early years and her flight from Cuba to escape Fidel Castro's regime (through Operation Pedro Pan), moving to the radically different state of Iowa at age 12, where she was separated from her family and everything she knew. This exile sparked an ongoing artistic search for identity and a sense of belonging. "I am overwhelmed by the feeling of having been cast from the womb (nature)," she said. "My art is the way I re-establish the bonds that unite me to the universe."

Equally, her art-making was linked to wider societal issues of female identity and sexual violence. In the 1973–1980 Siluetas (Silhouettes) series, for instance, Mendieta used her body to make indentations in the land, and female spirituality, magic, and ritual were alluded to through her additions of flowers and sometimes fire onto these outlines. She often appeared naked in her works—sometimes smeared with mud, sometimes with pores seeping blood—and the tones of her films and photographs are overwhelmingly fuelled by earthy, organic reds and browns.

She linked her own physical realities with metaphysical qualities in the world around her: "My art is grounded in the belief of one universal energy which runs through everything," she said.

1.

2.

3.

4.

5.

6.

Vincent van Gogh

Vincent van Gogh's famously dramatic, visible brushstrokes convey the sense of urgency with which he made his work. He was outrageously prolific, and made on average one painting every day in the 70 days leading up to his death in 1890, but his path to mastery was unhurried and systematic.

The drive to create artworks, often the same thing over and over, continued throughout the artist's entire career. He was largely self-taught, and in his early years he honed his craft by meticulously copying prints—creating more than 1,000 drawings in total in his early years alone—and would also meticulously follow the directions laid out in art instruction manuals. He wasn't afraid to make mistakes learning by trial and error what worked and what didn't, until he had mastered each aspect of his craft. His work ethic was relentless, and in his letters Van Gogh often spoke about other artists being more talented than he, but said that their talent was useless if they didn't work hard, like he did.

Though best known for his explosive, hyperreal use of color, these vibrant compositions didn't emerge until the last few years of his life. Van Gogh's earlier works are either monochrome or painted in muted, somber hues. In the background, however, Van Gogh was immersing himself in contemporary color theory, developing his own ideas and writing about them in detail to his brother Theo. In 1883 he wrote to Theo, "A certain feeling for color has been aroused in me of late when painting, stronger than and different from what I've felt before." In 1886 he moved to Paris and discovered the work of the Impressionists, but color was seemingly already a resource waiting to burst out of him.

Bob
Dylan

A eureka moment in Bob Dylan's songwriting arrived via Buddy Holly, who in a roundabout way taught him that "you can take influences from anywhere." The revelation came after Dylan heard that the refrain "that'll be the day" was a line in a movie, which Holly had stolen wholesale for his 1957 hit. "You can go anywhere in daily life and have your ears open and hear something," Dylan concluded. "If it has resonance, you can use it in a song."

As well as fortuitously overheard snippets, Dylan's writing draws on a vast variety of influences, from the poetry of the surrealists and the Beats to folk traditions, politics, and the imagery that rushed past him outside of train windows. " He is known to be a voracious reader—taking in everything from Dickens to Gogol, Balzac, Poe, Verne, and Byron to inform his work, both lyrically and thematically—despite claiming slightly obtusely that he had "never been that keen on books and writers," but "liked stories."

Dylan claims that the main work of writing songs is done by his unconscious, in which this great amalgamation of influences stew together until the song comes together seemingly by itself "like a ghost is writing a song." Then it is simply a case of writing it down. While this makes it sound like an all-too-easy and rather magical process, Dylan acknowledges equally the work that the writer must consciously put into it—whether by seeking out the ideas that inspire them or by pursuing the right mindset or environment to allow those ideas to flow. As he said, "Inspiration won't invite what's not there to begin with."

David Hockney

Throughout his six-decade career, David Hockney has embraced many different ways of working, and has frequently discussed his love of trying new approaches: "mediums can turn you on, they can excite you: they always let you do something in a different way."

Hockney's oeuvre takes in drawing, painting, printing, collage, photography, Polaroids, video, photocopies, faxes, and recent works created using an iPad. The limitations or possibilities of each medium forces new directions: using the iPad, for instance, Hockney missed the feel of working on paper, yet embraced the potential for working with color opened up by the digital medium. His 1980s photographic "joiners" assemblages were a response to his dislike of the distortions produced using wide-angle lenses in conventional photography.

His most famous work, *A Bigger Splash*, was created in 1967 using acrylics when his fascination with the reflections and kinetics of water drove him to return to the subject again and again. The Paper Pools series, created in 1978, saw him using colored and pressed paper pulp. This unusual medium forced him to simplify his work and become braver in his applications of paint. In the early 1980s, he returned again to the poolside, creating Polaroid photograph composite works such as 1982's *Sun on the Pool, Los Angeles* that challenged the idea of painting as the dominant mode of artistic expression.

When one thing stops working for Hockney, he explores something new. Hockney's work has always been explorative— stylistically, technically, and in his choice of subject. What unites it is a joyful search for newness that allows him to return to the same subject again and again through different means, and with fresh eyes, to generate beautifully diverse results.

95

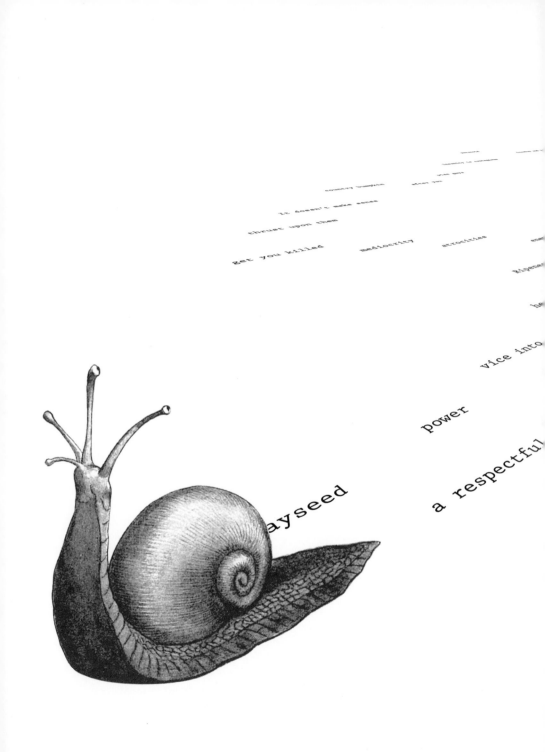

It doesn't make sense

thrust upon them

get you killed mediocrity atrocities

Ripen

vice into

power

a respectful

ayseed

Joseph Heller

Heller was, by his own admission, "a mysteriously slow writer." He claimed to have missed his deadline for *Catch-22* by four or five years. His reasoning was that it was his first novel, so he wanted to make it as great as possible. On a more practical level, he worked full time as an advertising copywriter so had only a few hours after work each day to be working on his debut. However, even after he was able to leave his nine-to-five, it took him 13 years from the publication of *Catch-22* to complete his second novel, *Something Happened*.

Curiously, he claimed that the first sentences of both *Catch-22* and *Something Happened* simply came to him, from which the other elements of the stories began to appear; and the same thing happened with their closing lines. They didn't necessarily remain—Heller eventually found a better opening line for his debut novel; and for six years he thought the closing line to his follow-up was going to be "I am a cow" before he discarded it ("I thought it was good at the time," he said). But the point seems to be that he needed a jumping-off point to kickstart his ideas, and an end in mind to direct them toward. What happened in between was a quite different process.

Heller's writing was a slow process of working rigorously section by section, submitting a more-or-less final version of each chapter to his agent and editor every year or so. Meanwhile, he made a huge amount of notes, keeping reference cards on aspects of his characters, as well as chapter outlines, plot points, sentences that came to him, and so on. He might spend two hours a day writing, but the lengthiest part of his process (and the reason for his missed deadlines) was the editing: polishing the prose, taming the humor, restructuring the plot. "I'm a chronic fiddler," the writer said; but in the end, it was all in pursuit of perfection.

Lena Dunham

They say that sometimes truth is stranger than fiction, and few writers manage to coalesce the two to such effect as *Girls* creator Lena Dunham.

Dunham has not shied away from creating characters, dialogue, and plot points from the people around her. Her father summed it up as "transforming the energy life throws at you into the folded bows of art," having realized that an argument between the two of them had rapidly been recycled into a narrative device.

Once Dunham gets down to the writing, she describes her process as "really musical," often making a playlist using songs that speak to the subject she's focusing on. Sometimes the songs on these make their way into the final cut, like when "Dancing on My Own" soundtracked the revelation that Hannah's boyfriend is gay in *Girls*, and became a thematic soundtrack over several episodes.

The fictional Shoshanna is heavily informed by one of the *Girls* screenwriters, Sarah Heyward: the writer's pop-culture references, girliness, obsessive list-making, and even her experience of losing her virginity all directly shaped her onscreen counterpart's personality and experiences. Hannah Horvath, Dunham's character in *Girls*, also frequently blurs the lines between the actor and the fiction. In portraying Horvath's relapse into obsessive-compulsive disorder, Dunham drew on her own highly personal experiences of the condition, recreating her own tics and quirks for darkly comic purposes. "We definitely were using little things that had happened to me and to Lena. It wasn't just me," says Heyward.

Frida
Kahlo

Trauma and the creative process are age-old bedfellows, and if there's one artist who demonstrated the beauty that can be wrought from personal tragedy, it's Frida Kahlo. Her early life was punctuated with misfortune: childhood polio left her with a stunted right foot and a limp, and when she was 18 she suffered a terrible motor accident that left her bedridden for three months. It was then that she started painting.

Kahlo used painting to explore her life and the catastrophes that shaped it. She primarily painted still lifes and portraits of herself and the family and friends close to her, as though art were something very much aligned to her own identity rather than a commodity created for an audience.

As an adult, Kahlo's beloved husband Diego Rivera was frequently unfaithful (she later also had affairs), and she went through several miscarriages and abortions. The artist immortalized these events on canvas, such as in her painting *Henry Ford Hospital*. Created after a miscarriage, the piece is a graphic representation of solitude and despair; a self-portrait depicting a naked, crying woman in a pool of her own blood, multiple umbilical cords flowing from her hands and leading to eerie, surreal objects—a snail, medical models, a withered flower head.

Kahlo's works are open and brutal, transmuting her grief into things of beauty that move the world. She did not hold back in depicting her pain, but neither did she fruitlessly dwell on it. Instead, in her painting, she was tearing it out of herself: one half of her post-divorce work *The Two Fridas* literally sees the artist tear open her clothes to reveal a broken heart.

Nan Goldin

Nan Goldin's photography is renowned for its unflinchingly honest portrayals of life, love, sex, and friendship. What makes her work so compelling is the way she makes the private public while retaining the sense of intimacy. Her real life and the relationships that form it are intrinsic to the work she makes.

Goldin's most famous work, the 1980s collection *The Ballad of Sexual Dependency*, demonstrates her ability to succinctly touch the most personal parts of life—beginning with its title. Throughout the collection, the reds, pinks, and purples of bruises, soft furnishings, and night-lit interiors paint a picture of good times and bad times, as if inviting us into memories.

In part, this intimacy is the product of stylistic choices: a candid approach that places us in the center of the action, the rich colors that bring intensity to every scene, and lighting that somehow always looks artificial and stark, even when it is natural. The photos resemble the snapshots that ordinary people take and amass over years to create a kind of personal history; as Goldin said, people take these kinds of photos "out of love, and they take them to remember."

Mostly, the intimacy she captures is possible only through the adoration and respect she has for her subjects, most of whom are her closest friends or sometimes her lovers: "My work has always come from empathy and love," she's said. Goldin lived among the people she photographed—her "tribe" of misfits and outsiders. Nothing is composed and nobody poses: hers are images of real life as she sees and lives it. Some of her most powerful images are her portrayals of the group of drag queens she fell in with in the 1970s, and her adoration of them imbues each shot: "I thought they were the most beautiful people I'd ever met in my life."

Stephen King

Stephen King is one of the most startlingly prolific writers of the past 50 years, jokingly describing himself as the "literary equivalent of a Big Mac and fries." He began submitting stories to magazines at just 13 years old and had already completed five novels by his junior year of college. On finding success, this intense work ethic showed no signs of abating: he claims that he writes every single day—even on Christmas.

King sees that the more you write "the more trained you are to recognize the little signals" that could form the kernel of a plot. Good story ideas, he says, seem to come "quite literally from nowhere," and the writer's job is simply to recognize them when they show up. Practice is also necessary for executing your craft effectively. He argues that the paragraph, rather than the sentence, is the "basic unit" of writing—a "marvelous and flexible instrument" honed only through hours, days, weeks, and years of practice.

But King's notion of practicing your craft doesn't mean just frequent writing; it is also essential to read as much as possible. Throughout his life King has always had a voracious appetite for stories, whether in the form of horror movies, poetry, classic fiction, or pulpy airplane novels. For him, even reading "bad" literature makes a writer better; and often reading "bad" books can teach the aspiring writer more than "good" ones.

He stresses that good writing is the product of hard work, dedication, and striving to master the items that make up a novelist's "toolbox": vocabulary, grammar, and elements of style. How to find those? Just keep on writing and reading; then writing and reading some more. There is such thing as a muse, he says, but "you have to do all the grunt labor."

Tracey Emin

Emin made a name for herself through deeply confessional and occasionally controversial work. Whether she's working in neon, paint, textiles, ink, or found-object installations, such as her 1999 Turner Prize-nominated *My Bed*, her pieces frequently draw directly on her own life.

The power of Emin's work lies in the fact it comes from a disarmingly honest place that few others would dare to plunder: "I've been drawing myself all my life," she's said. As such, her artwork titles often feel like snippets from a journal—*Sad Shower in New York, Mad Tracey From Margate. Everyone's Been There*, and the self-portrait *Sometimes I Feel Beautiful*.

Her first solo show at the White Cube in 1993, *My Major Retrospective*, was entirely autobiographical. It presented personal photographs, early paintings, and objects that often told harrowing stories of her life, including the cigarette packet her uncle was holding when a car crash decapitated him. Similarly, *My Bed* took the form of a no-holds-barred found-object installation of the bed she'd lain in for a week feeling suicidal, replete with bloodstained underwear, dirty sheets, used condoms, and vodka bottles. It was her life directly transformed into art, and a hugely brave (yet much debated) statement.

For Emin, being an artist isn't about being a "picture maker," but about "the essence and integrity" with which the work is made. It's not about prettiness, it's about something that is true and honest. Perhaps this makes one's own self the hardest subject. If Emin's work can appear self-lacerating, the statement is, however, fundamentally positive: early on in her career she came to the conclusion that "I was much better than anything I'd ever made." She says, "I realized I was my work, I was the essence of my work."

Truman
Capote

Truman Capote's 1966's work *In Cold Blood* was the result of a journalistic mind married with the narrative sensibilities of a novelist. The story details the quadruple murder of the Clutter family in Holcomb, Kansas by Richard Hickock and Perry Smith. Capote purported that the book was a new literary art form which he dubbed the "nonfiction novel."

By adopting journalistic methods, Capote stressed the importance of certain skills that were lacking in fiction writers. These were an ability to transcribe long conversations verbatim without notes or recordings—he claimed he had trained himself to get within "95 percent of absolute accuracy" —an impeccable eye for visual detail, and an affinity for empathizing with people outside of their usual spheres. *In Cold Blood* was also the product of exhaustive journalistic research: Capote spent months in Kansas gathering details, and he later said his files, clippings, letters, and court records would almost fill a small room.

Capote dismissed the idea that such a form demonstrated a "failure of imagination," as some critics suggested. The choice of material, the angle, the details he focused on— Capote was open about how details were "selected" and arranged to heighten narrative tension and intrigue—all these things required imagination. Rather than narrating the murders and trial through a journalistic or biographical lens, Capote combined real-life events with literary and poetic sensibilities. He found a story he wanted to tell, and told it in an original way that forged new ground in literature.

Albert Einstein

Mozart's sonatas might seem a million miles from Einstein's theories, but the links between music and science are as old as the disciplines themselves. Isaac Newton's groundbreaking color theory, for instance, was inspired by the idea that the range of the visible spectrum was analogous to the seven-note musical scale, while Pythagoras pioneered the expression of musical intervals through simple mathematical ratios.

Einstein played the piano and violin from a very early age, developing a particular fondness for Mozart and Bach. On the day the general theory of relativity was proved right, in 1919, he celebrated by buying himself a new violin. While playing music was partly a recreational pastime for Einstein, it also served a purpose of helping jolt an idea or solution into being. If he found himself unable to solve a problem in his physics work, his refuge would be music, and this often helped to creatively guide his thoughts into new directions.

He saw links between the harmoniousness of music and that of the natural world and the universe, and often spoke of thinking in terms of feelings and musical architectures rather than logical symbols or mathematical equations. "The theory of relativity occurred to me by intuition, and music is the driving force behind this intuition," he said. While he acknowledged the connections between scientific and musical processes, he embraced their differences so that one stream of creativity could inform the other.

Above all, Einstein recognized the power of intuition. When he considered himself and his methods of thinking, he concluded that "the gift of imagination has meant more to me than any talent for absorbing absolute knowledge."

Werner Herzog

As part of director Werner Herzog's famous Rogue Film School, he tells his students that the most important thing they can do to become a filmmaker is to "Read, read, read, read. And then read some more."

The self-taught filmmaker has strong ideas about what makes a great director or documentarian: it's not necessarily the one who's swallowed the film theory class whole, or the one with the greatest technical ability, but the one with a real story to tell. The best way to learn how to tell a story is to read a book; and not one about filmmaking, scriptwriting, or editing, but one that tells a story itself. "People do not read enough, and that's how you create critical thinking, conceptual thinking. You create a way of how to shape your life," he says.

Herzog says that he spends only five days writing a screenplay, and that if you're spending more than two weeks on it, "something's wrong." By the time he actually sits down to put his ideas onto paper (or screen), he arrives with a story and idea almost fully formed, as though "copying" straight from his mind. In order to be able to do this, he claims to spend the four or five days preceding the act of writing engrossed in reading only poetry—consuming everything from Chinese poets of the eighth and ninth centuries to old Icelandic poetry to German poets like Friedrich Hölderlin. According to Herzog, while these texts have nothing to do with the film he's making, the "frenzy of high-caliber language and concepts and beauty" are crucial in laying the foundations to underpin his own writing.

Anaïs
Nin

The thousands of pages Anaïs Nin compulsively wrote in her journals, from her early childhood to her death, are as much a part of her oeuvre as her novels. Journaling was a way for Nin to process and ponder the life she lived so vividly, a life enriched and confused by the fascinating characters she surrounded herself with: Henry Miller, Antonin Artaud, and Gore Vidal, to name a few.

Although the turbulent relationships she had with such men often caused her pain, Nin's diaries reveal a determinedly open and generous nature. She often speaks of the importance of "living"—how hibernation and isolation are fatal to her both emotionally and in terms of her ability to write well. Conversely, writing has the power to elevate whatever it touches: "We write to taste life twice, in the moment, and in retrospection. We write to be able to transcend our life, to reach beyond it."

For Nin, anything at all outside of the self is potential inspiration: "everything can nourish the writer," she states, be it the dictionary, a new word, a voyage, an encounter, a conversation overheard on the street, a book, or a new phrase.

Nin believed that keeping her diaries enabled her to organize the confusion of life, and, as such, help to arrive at a more objective understanding of it. The spontaneity and unselfconsciousness that writing in a journal facilitates gave her first a more nuanced view of her own identity, and then a deeper understanding of the world and others, laying the foundations for her works of fiction.

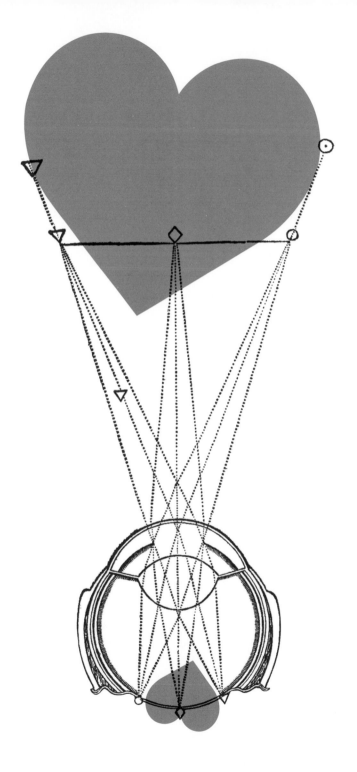

Milton Glaser

Designer Milton Glaser is behind some of the most recognizable logos, identities, and graphics of the past 50 years. Clearly he's had some great ideas, and he firmly believes that creative block fundamentally doesn't exist. To be a great designer involves skill—he's a huge advocate for designers honing the craft of drawing—and sharpening your powers of observation to ensure that as a creative you are always truly "seeing" the world.

Idea-generation is all about making connections, constructive play, and working hard until something forms on the paper or the screen that works for that particular project. However, he concedes that the best ideas don't always happen when you're trying to force them into being. When he was creating his I Love New York logo (better recognized as "I [Heart] NY"), the idea came to him in the back of a cab. How? Because he is "always in a receptive state," as he puts it, "I don't have an idea that there's an 'appropriate' time for work." Very often, he says, an idea for a project he was working on yesterday, or intends to work on tomorrow, will come to him when he's doing something totally unrelated.

That 1977 design is as ubiquitous today as it ever was, and Glaser attributes that to the fact that he made it from a place of clarity: it wasn't for an agency or client, but was created as a succinct reflection of what he saw that the people of the city were feeling at the time.

True creativity involves letting go of preconceptions about what you're seeing, or what you're about to see, and using the powers of observation in the here and now. Otherwise, he says, "you don't really see it."

117

Yoko
Ono

Yoko Ono's conceptual art practice centers around making the audience active participants, rather than passive observers. One of her earliest pieces was 1960–61's *Painting to Be Stepped On*. Ono placed a canvas on the floor, which was completed only once visitors had stepped on it, leaving their footprints. *Cut Piece*, created a few years later, was realized only through audience participation. The performance piece involved Ono sitting wearing a suit with a pair of scissors before her. She invited the audience to join her and cut off pieces of her clothing.

The reactions to those works couldn't be predicted: Ono simply created the instructions and setting, then let the reactions of others shape their outcomes. By working this way, she forms an unusual dialogue and collaboration with people she may never even meet—her audiences are the ones formally completing her work, making them a vital co-creator of her art.

Ono preaches spontaneity and a resolution to be positive. She's often spoken about her time mourning the loss of her husband John Lennon, and how she forced herself to look in the mirror each day and smile, even when it felt impossible. This impulse and the belief in the power of collective human positivity was first realized in her 1968 *Film No. 5 (Smile)*, a slow-motion film of Lennon smiling, but has more fully come to fruition in her ongoing project *#smilesfilm*, an online participatory artwork formed from user-submitted images of people smiling from around the world. Without the participation of others, there would be no artwork.

The artist's reliance on others to actualize her pieces means part of the creative process is in sitting back: "My strength is in not planning," she says. "I just let things happen."

CREATIVITY RIDGE

MEMORY BRIGADE

ARTILLERY OF LOGIC

CAVALRY OF METAPHOR

Honoré de Balzac

Legend has it that French novelist and playwright Honoré de Balzac consumed the equivalent of 50 cups of coffee every day, claiming that caffeine forced his creative ideas to "quick-march into motion" and for memories to "come up at the double." He had no doubt that "were it not for coffee one could not write, which is to say one could not live."

It's thanks to the effects of caffeine that Balzac was able to maintain his peculiar and surely exhausting work schedule. He ate a light dinner at 6pm, went to bed, and awoke again at 1am to work for seven hours at his writing table. Come 8am, he took a nap for an hour and a half, then it was back to work from 9.30am until 4pm. The writer described this existence as "orgies of work punctuated by orgies of relaxation and pleasure."

In his 1839 essay *Traité des Excitants Modernes* (*Treatise on Modern Stimulants*), Balzac revealed that as well as black coffee, he also ingested caffeine by pulverizing coffee beans into a fine dust and ingesting the dry powder on an empty stomach. This was sufficient to start a veritable onslaught of creativity: "Ideas quick-march into motion like battalions of a grand army... Memories charge in, bright flags on high; the cavalry of metaphor deploys with a magnificent gallop; the artillery of logic rushes up with clattering wagons and cartridges; on imagination's orders, sharpshooters sight and fire; forms and shapes and characters rear up; the paper is spread with ink."

While substance abuse has a long history in the annals of creativity, it's never advisable—even when the substance in question is something as innocent as coffee. Balzac suffered from ailments including stomach cramps, facial twitches, headaches, and high blood pressure, and he died of heart failure aged 51.

Rei Kawakubo

Since it was established in 1969, Comme des Garçons has enjoyed huge critical and commercial success and has had a profound influence on the fashion world. But founder Rei Kawakubo's stance is distinctly anti-fashion, challenging all the norms and ideals associated with the industry and making garments that are startlingly conceptual in their form, punk-leaning, and always unlike anything that came before them. The boldness and originality of her designs are the product of hardline creative purpose, driven by the pursuit of newness.

In Kawakubo's "creative manifesto," published in 2013, she talks about how traditional sources of inspiration are in fact limiting because they offer only things we have seen before. Where many would look to museums, galleries, films, peers, "silly magazines," or people on the street, the designer instead waits "for the chance for something completely new to be born within myself."

The process of engendering this new thing is one of strictly enforced creative limitations, whether that might be creating garments out of only one square of fabric, the specificity of the abstract image or concept she begins from, or taking an old pattern piece and using it in an unexpected way. "I think about a world of only the tiniest narrowest possibilities," she says, "nothing new can come from a situation that involves being free or that doesn't involve suffering."

Few designers are as hard to pin down as Kawakubo, but if she has a process it is one of stripping away all traditional notions about fashion and working "in the void," to the most extreme extent. In making her SS14 collection, for instance, she says, "I tried to think and feel and see as if I wasn't making clothes."

Walter Gropius

If for many artists, life imitated art (and vice versa); one of the key principles for architect Walter Gropius and the Bauhaus school he founded was that art should be integrated into all aspects of life. His designs were shaped by the belief that whatever we surround ourselves with, whether buildings, furniture, or homeware goods, can have both art and practicality underpinning them.

Gropius believed that beauty and quality should be tenets within every home, not just those of the upper classes. His advocacy that "form follows function" was born of an egalitarian view of minimalism in which unnecessary decoration was a signature of frippery and undemocratic ostentatiousness. With the new era of mass production, Gropius saw that art could be made available to everyone, from the buildings they worked in to the handles on their cupboards. He sought to create a new "modern" design ethos based on the idea that creativity should move things forward, not reference the past, and therefore new technologies, and newly available materials like glass and steel, were a key part of his aesthetic.

His designs were essentially about problem-solving: reacting to the most pertinent issues of the day through art and design, and embracing the latest technological advances for their potential. In this way he is the forerunner of many of today's designers who are increasingly focusing on issues such as sustainability or maximizing the ever-shrinking space we have in urban life.

Imagination
is more important
than knowledge.

Knowledge
is limited.
Imagination
encircles the world.

— Albert Einstein

ACKNOWLEDGMENTS

Huge thanks to my mum, whose kindness and
generosity blows my mind, to the rest of
my family for being wonderful, and to Sean,
whose creativity and support I couldn't
have done this without.